POODLES
lightweights **littermates**

sharon montrose

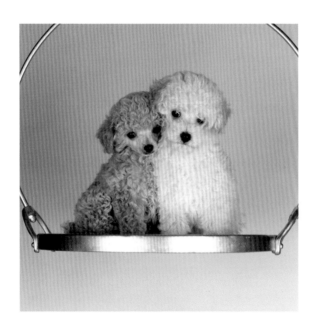

Stewart, Tabori & Chang

New York

Published in 2007 by Stewart, Tabori & Chang
An imprint of Harry N. Abrams, Inc.

Library of Congress Control Number: 2007928304
ISBN-13: 978-1-58479-636-7
ISBN-10: 1-58479-636-7

Designer: Sharon Montrose
Editor: Kristen Latta
Production Manager: Tina Cameron

The text of this book was composed in Eatwell Skinny & Eatwell Chubby by Chank Diesel.

Printed and bound in China.

10 9 8 7 6 5 4 3 2 1

HNA ■■■■■
harry n. abrams, inc.
a subsidiary of La Martinière Groupe
115 West 18th Street
New York, NY 10011
www.hnabooks.com

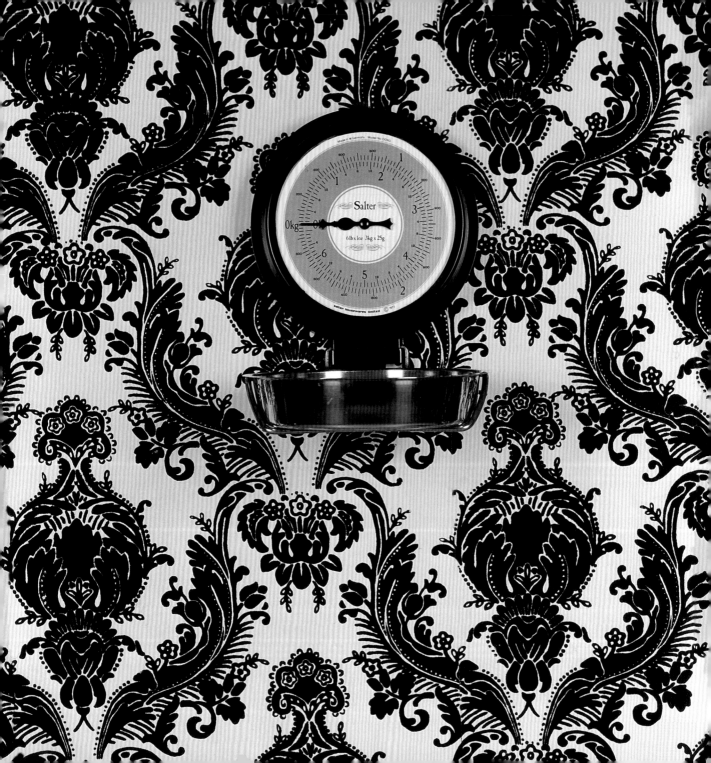

lightweights littermates eight weeks old

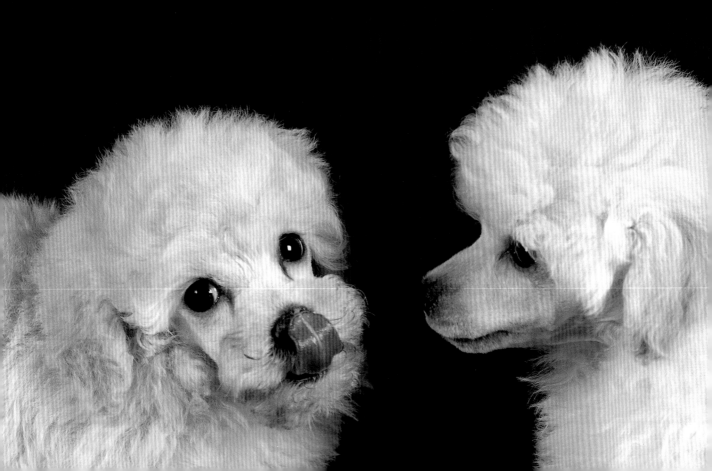

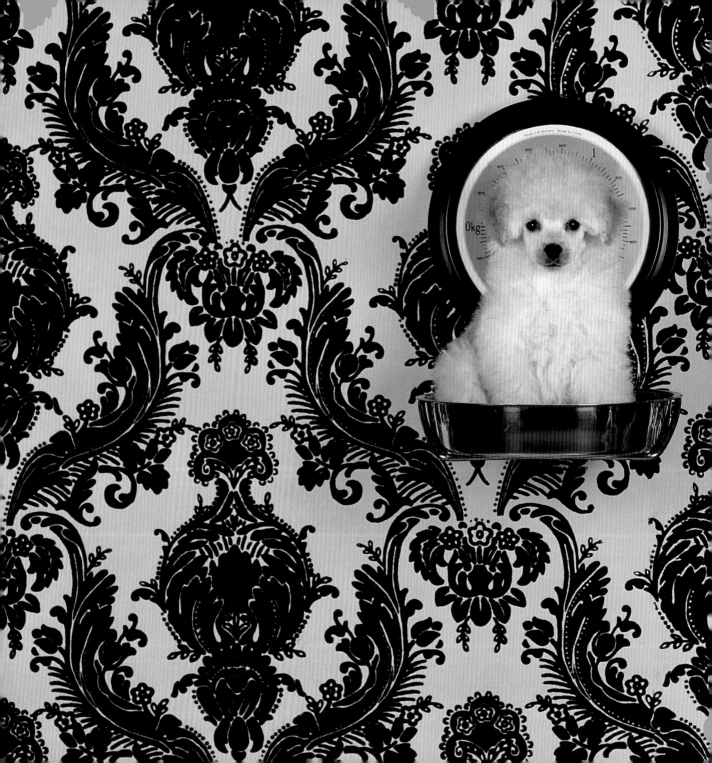

ronnie O lbs. 15 ozs.

reginald O lbs. 14 ozs.

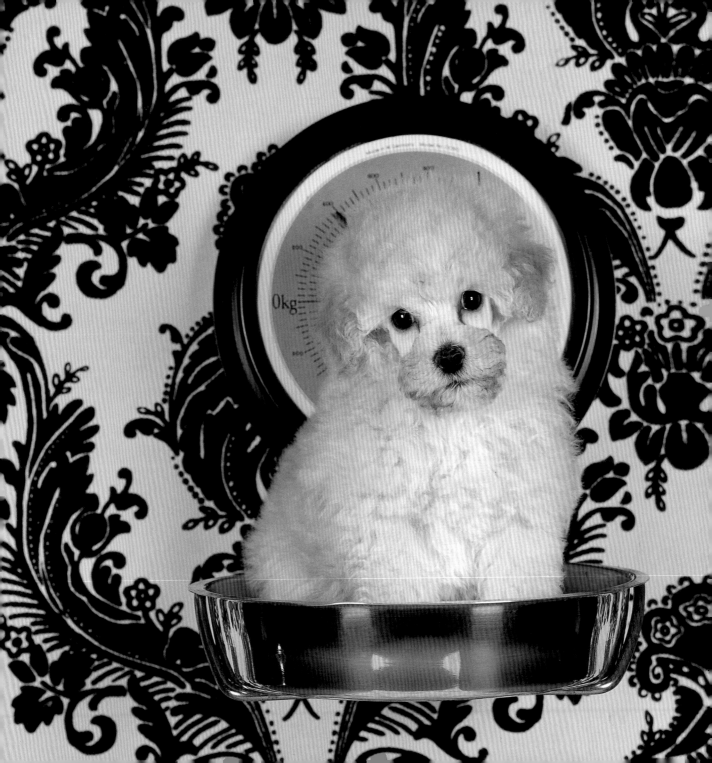

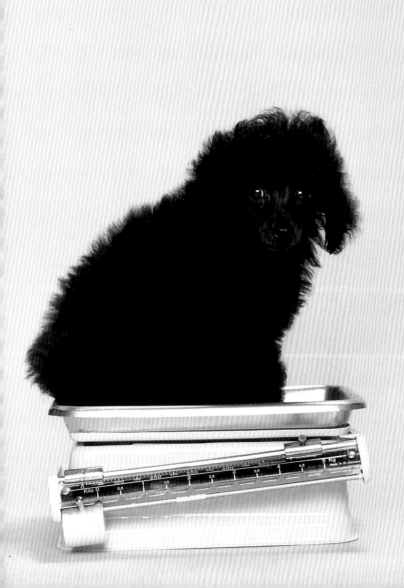

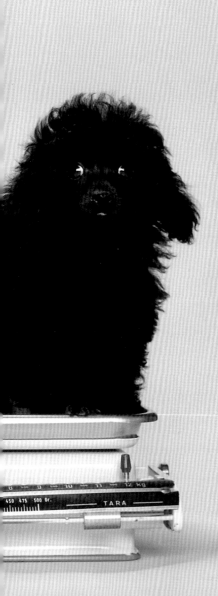

lightweights **littermates** eight weeks old

larry 2 lbs. 2 ozs.

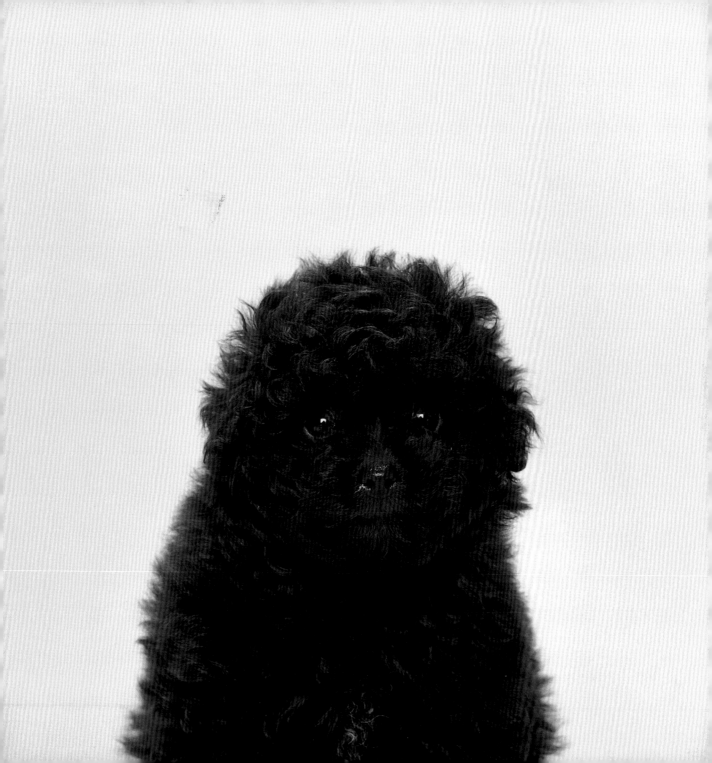

rhonda **2** lbs. **8** ozs.

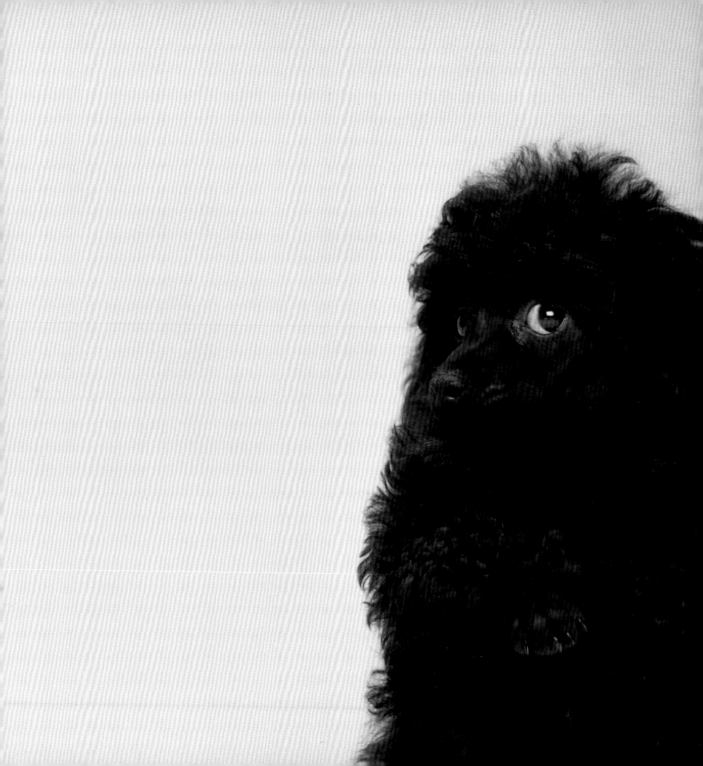

sis 2 lbs. 5 ozs.

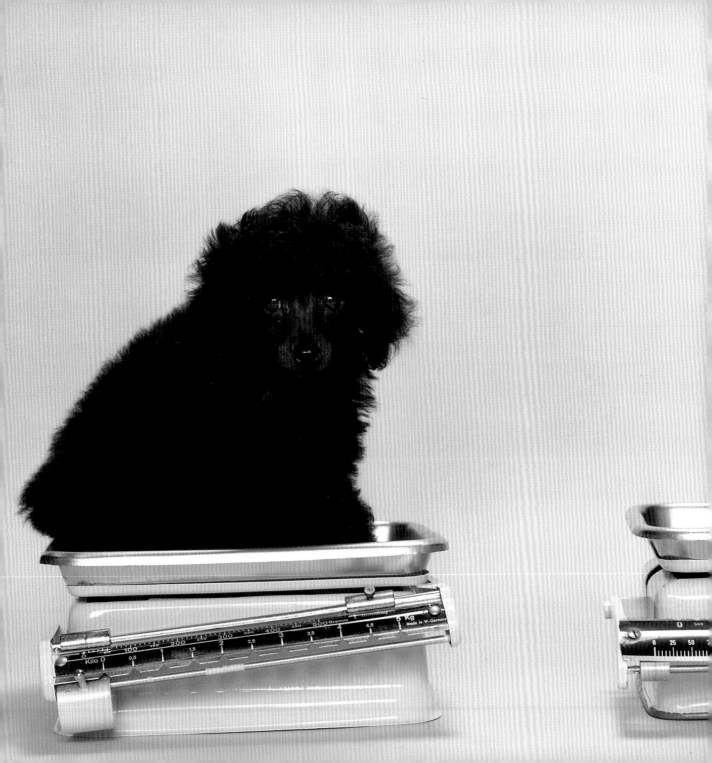

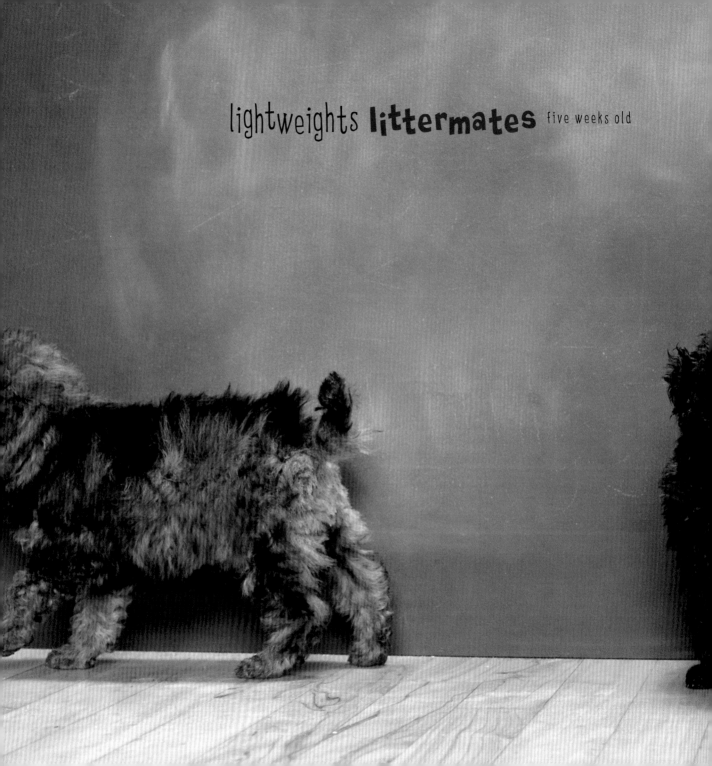

lightweights **littermates** five weeks old

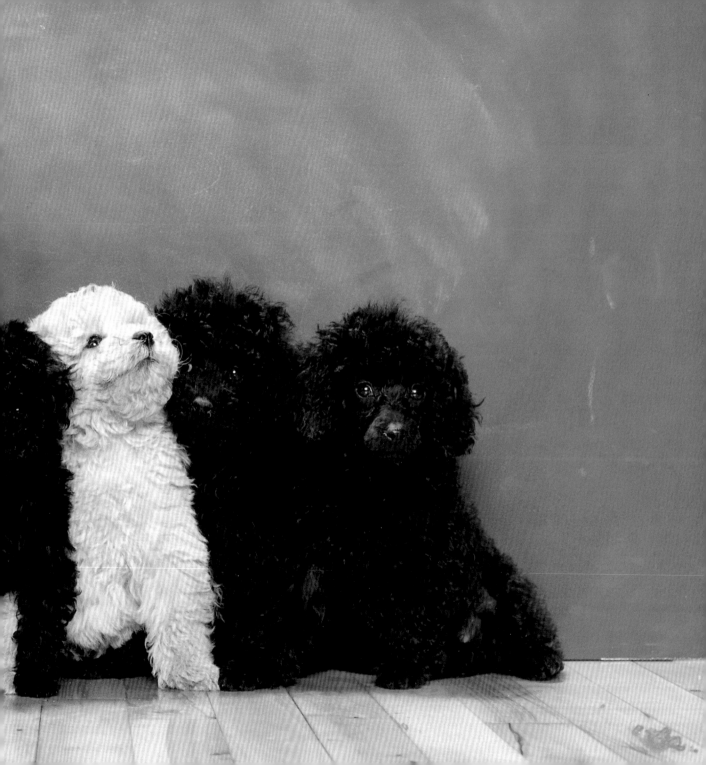

teddy 3 lbs. 2 ozs.

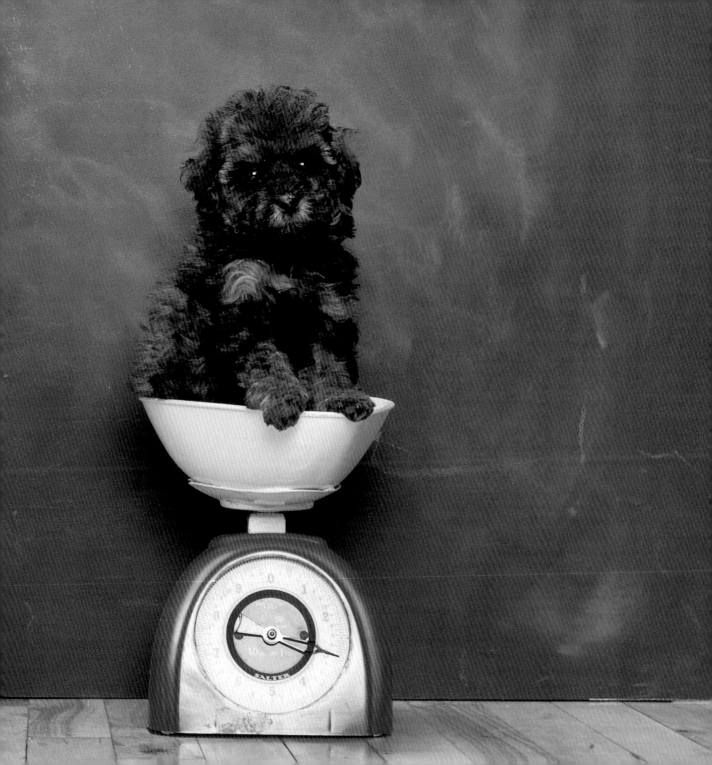

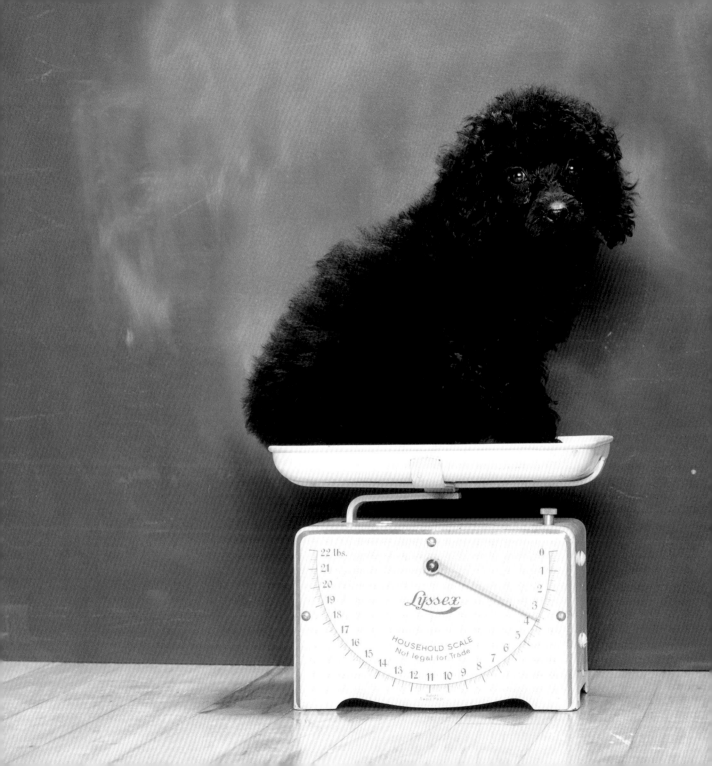

georgia 3 lbs. 4 ozs.

hamm 2 lbs. 14 ozs.

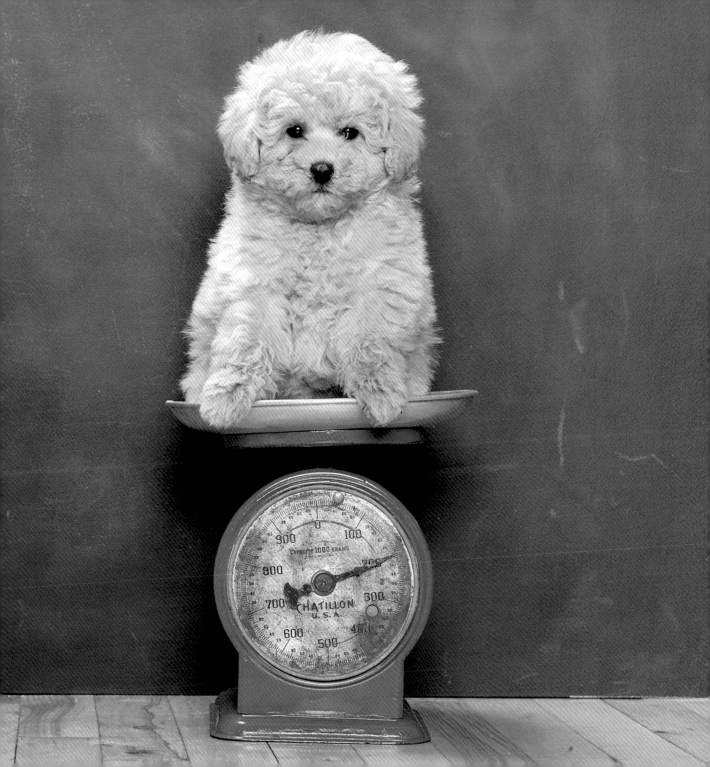

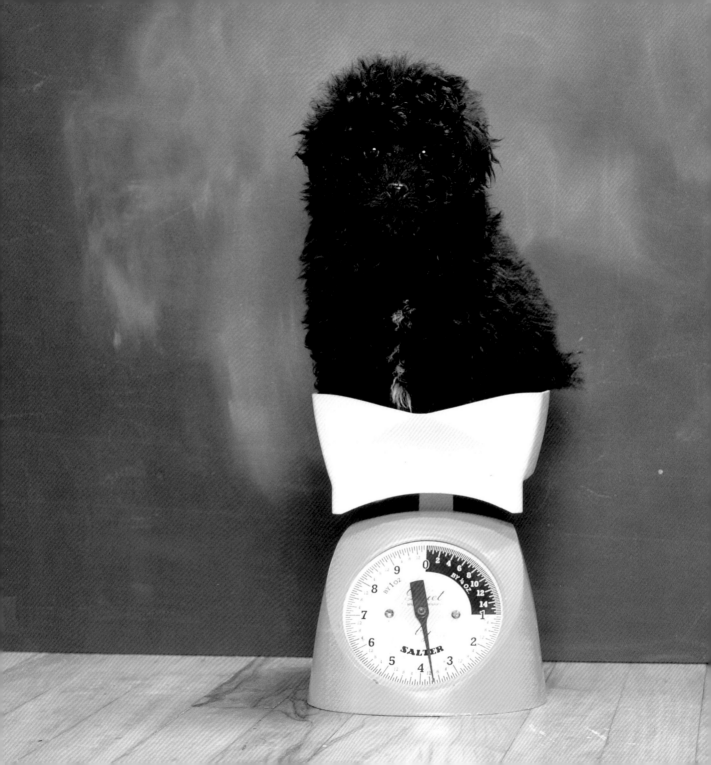

ord 3lbs. 8ozs.

darla 2 lbs. 5 ozs.

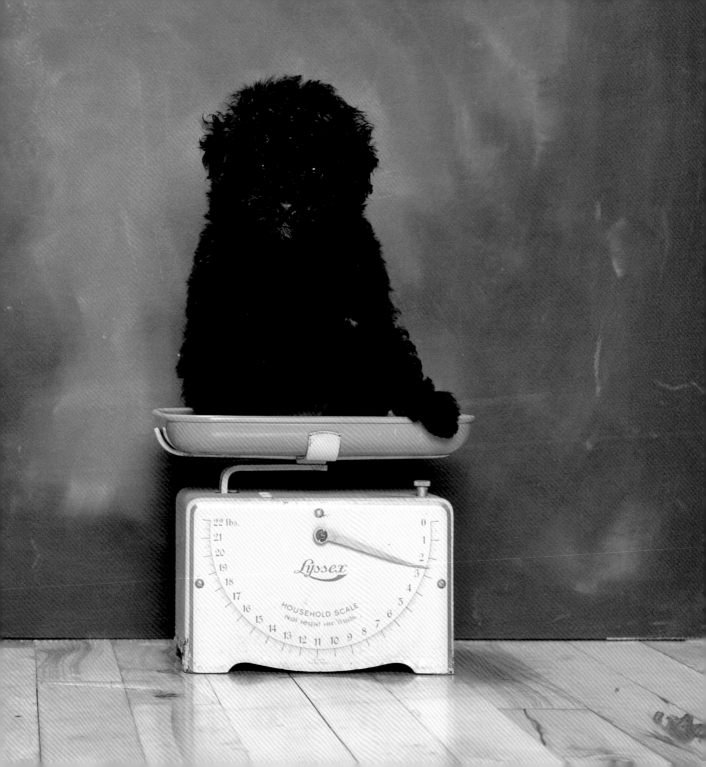

lightweights littermates four weeks old

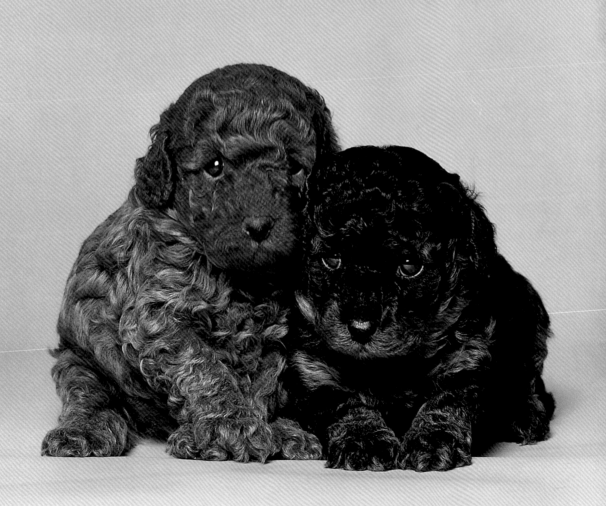

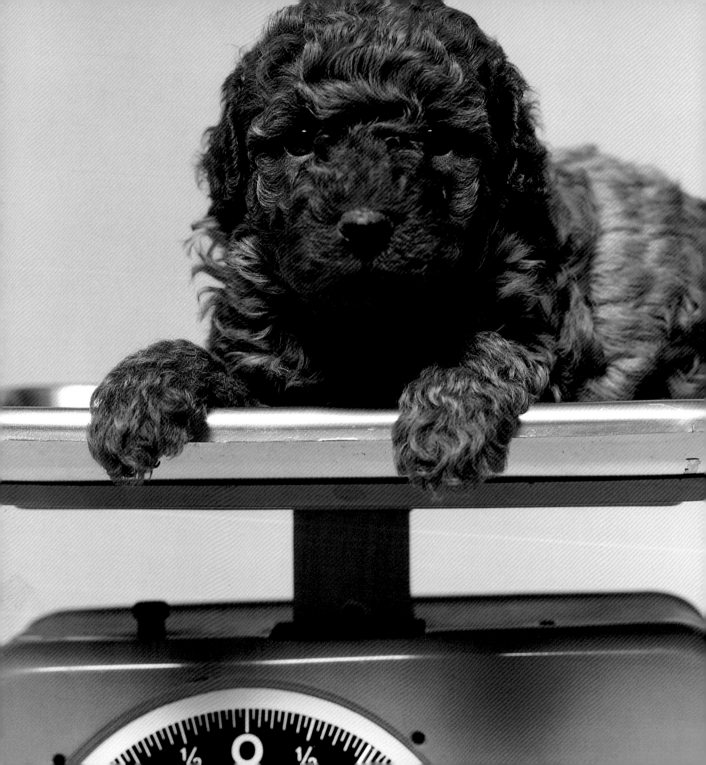

branford 2 lbs. 4 ozs.

wynton 2 lbs. 2 ozs.

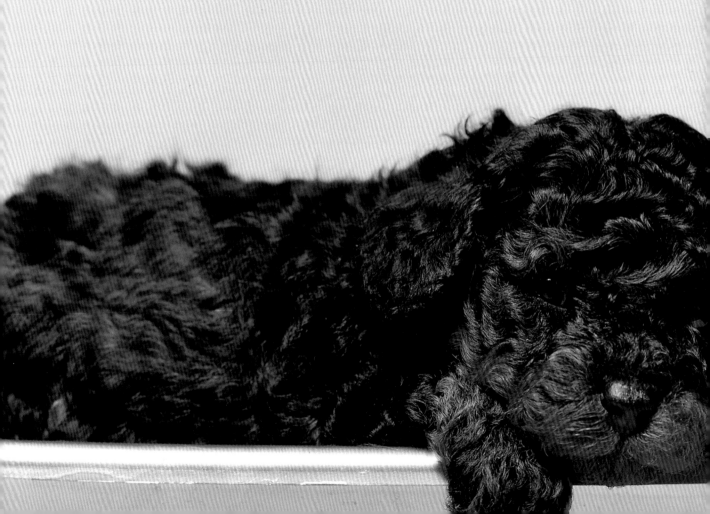

combined weight 1 lb. 4 ozs.

lightweights littermates four days old

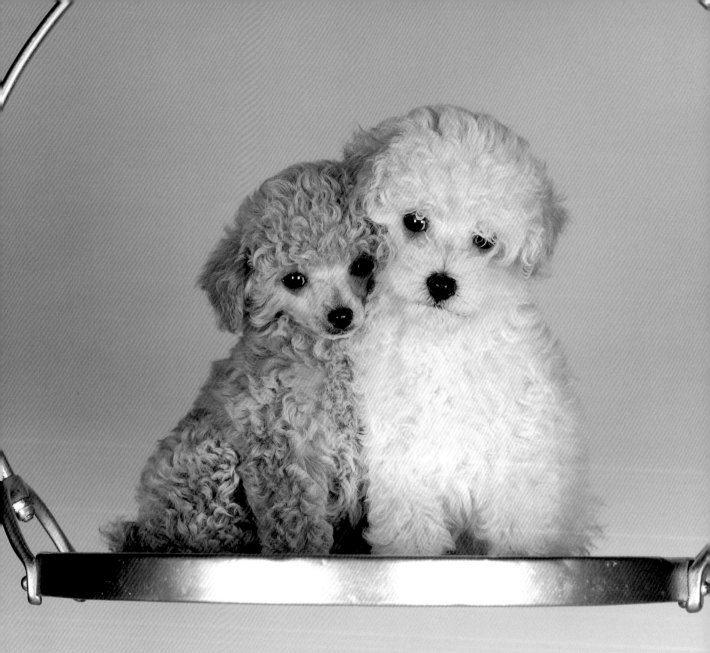

lightweights **littermates** seven weeks old

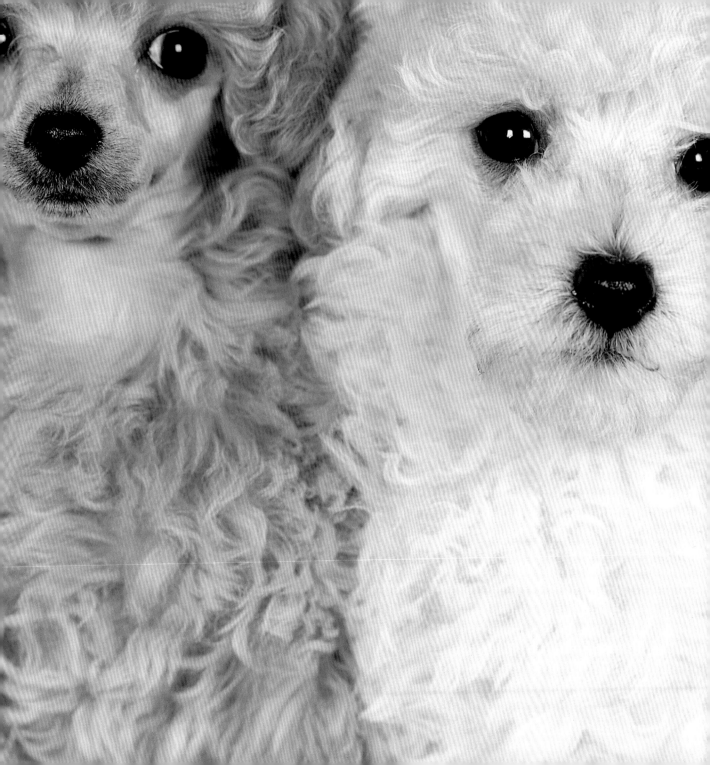

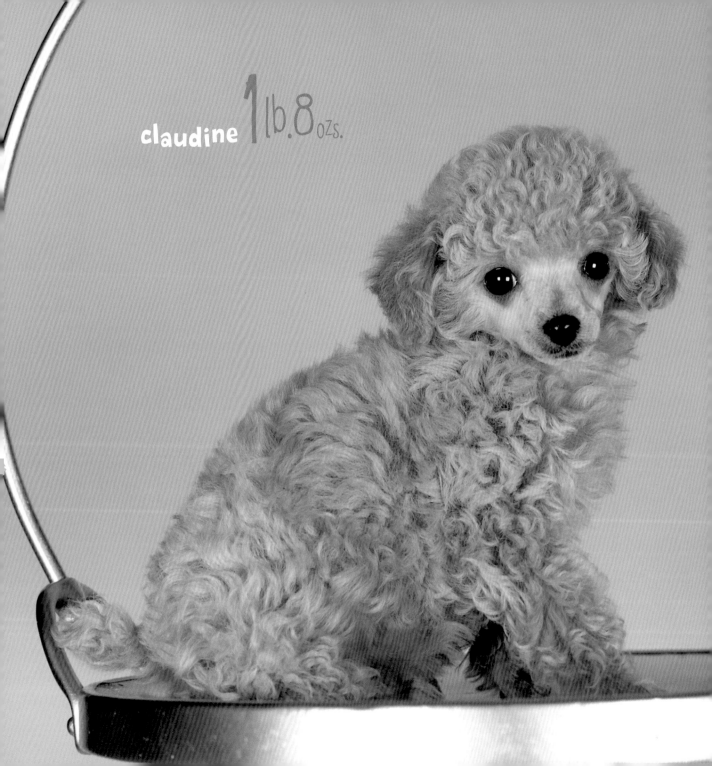

claudine 1 lb. 8 ozs.

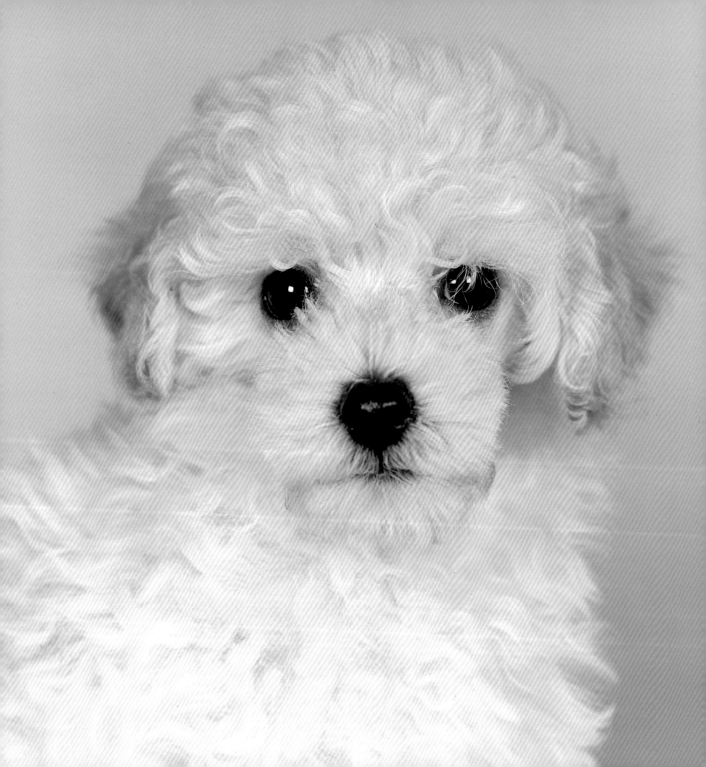

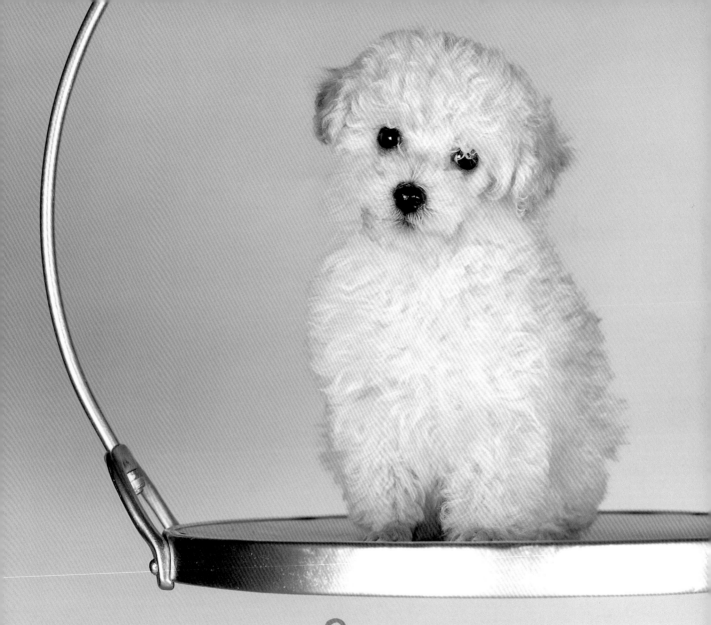

pascal 2 lbs. 0 ozs.

lightweights **littermates** _{nine weeks old}

three of six

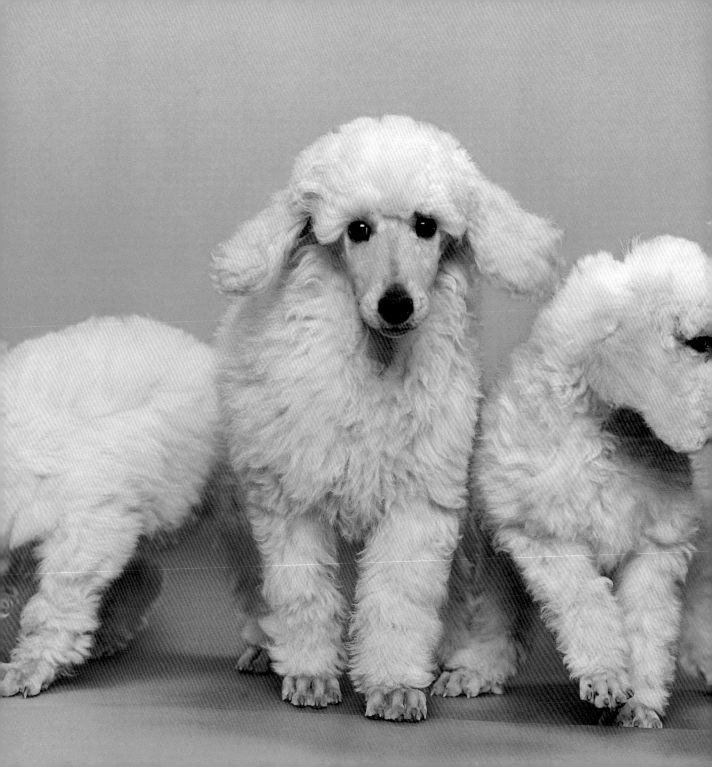

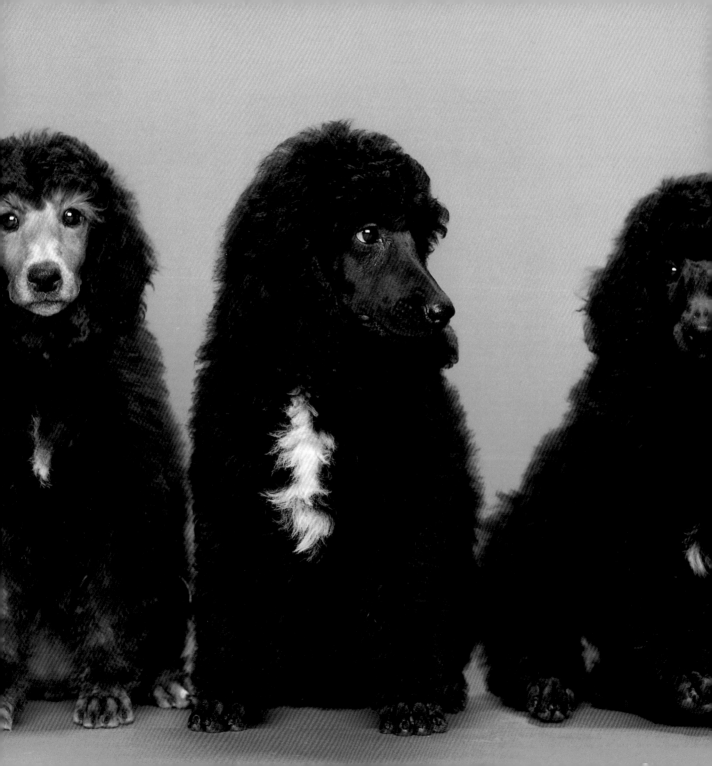

lightweights **littermates** nine weeks old

three of six

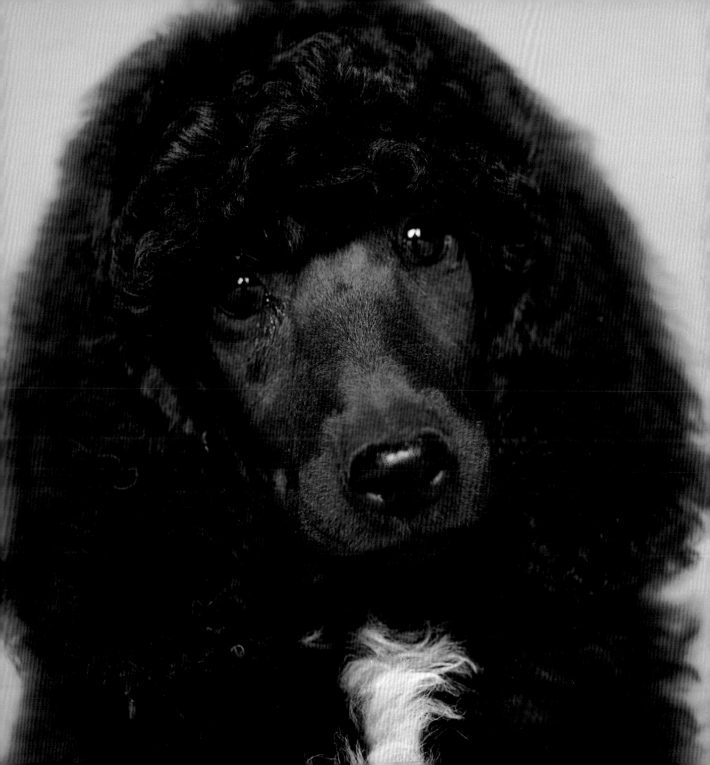

anne bonny 8 lbs. 15 ozs.

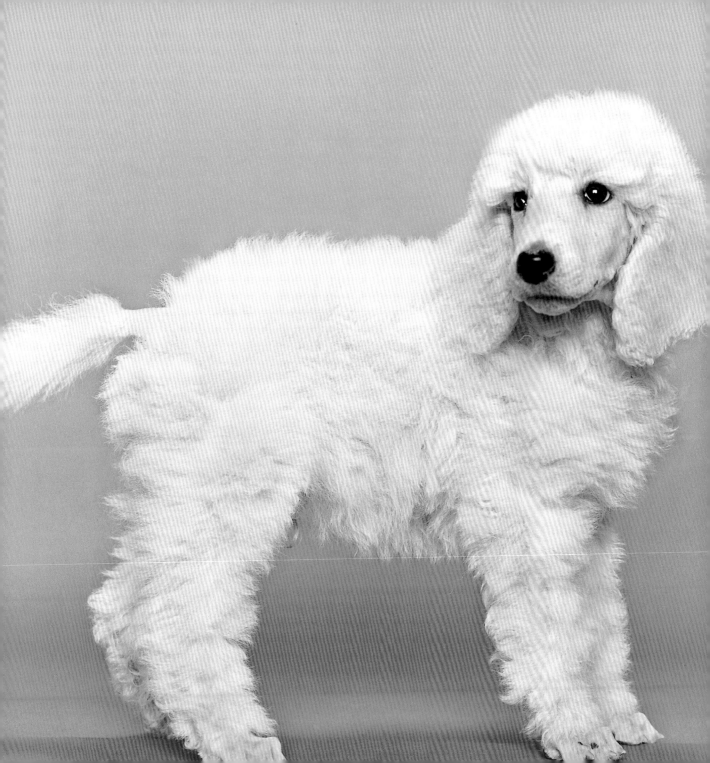

sir drake 8 lbs. 2 ozs.

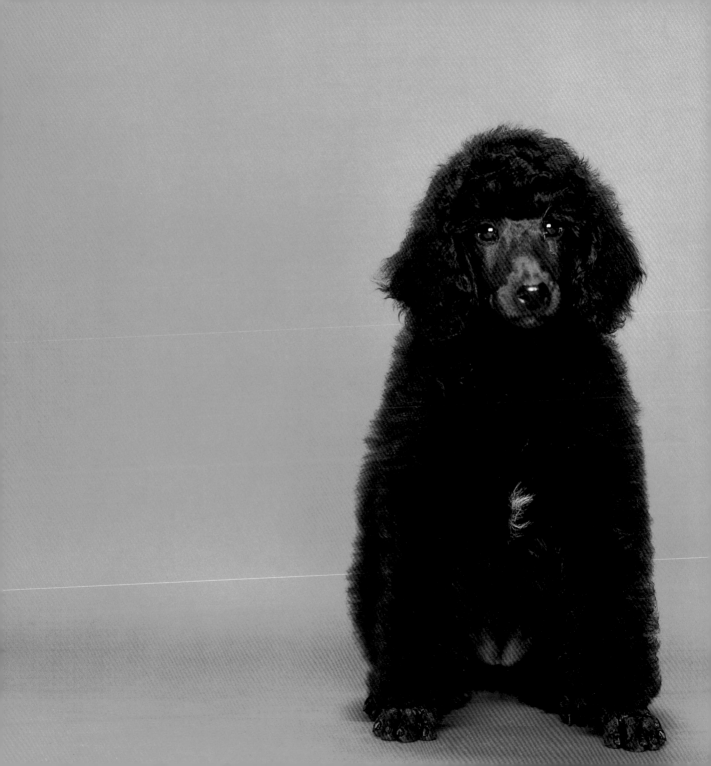

stede 9 lbs. 8 ozs.

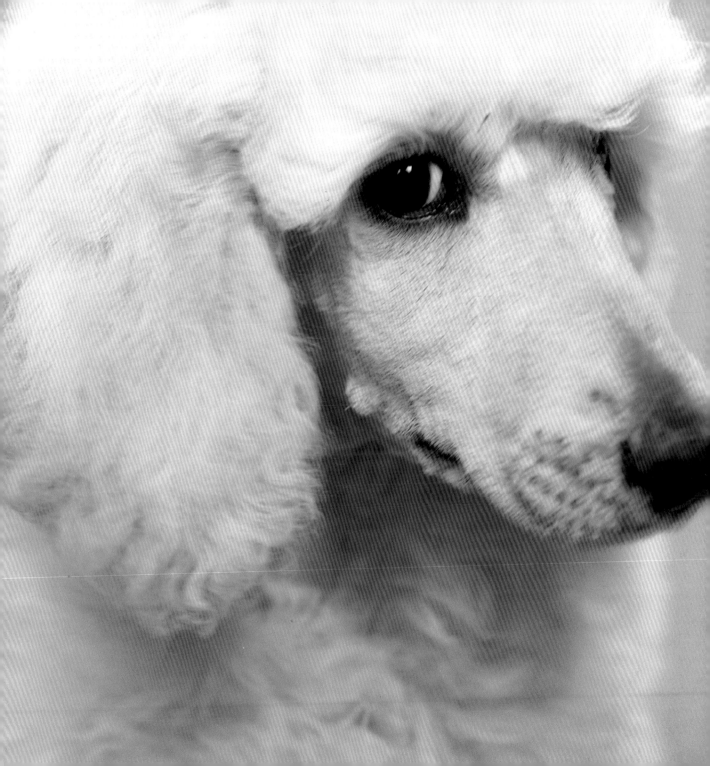

bluebeard 8 lbs. 6 ozs.

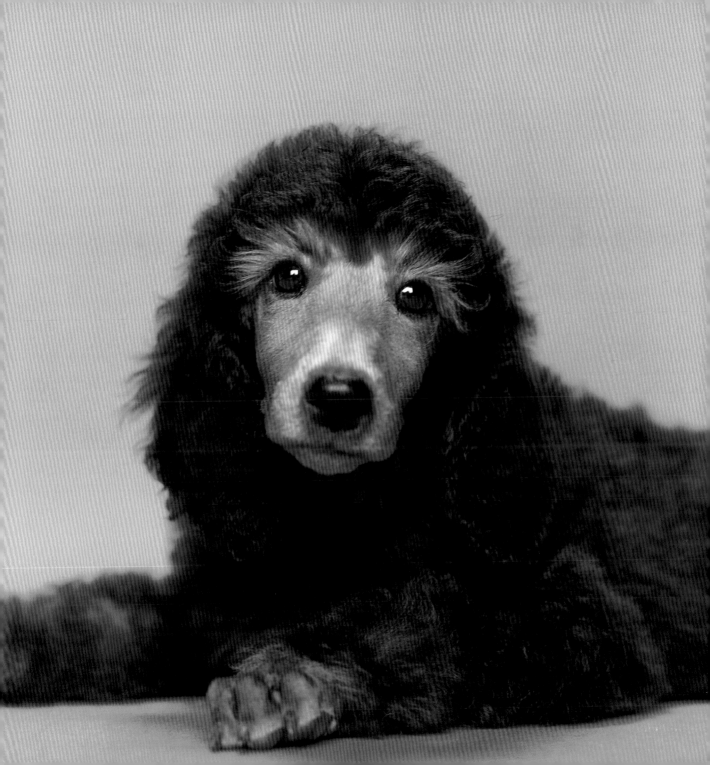

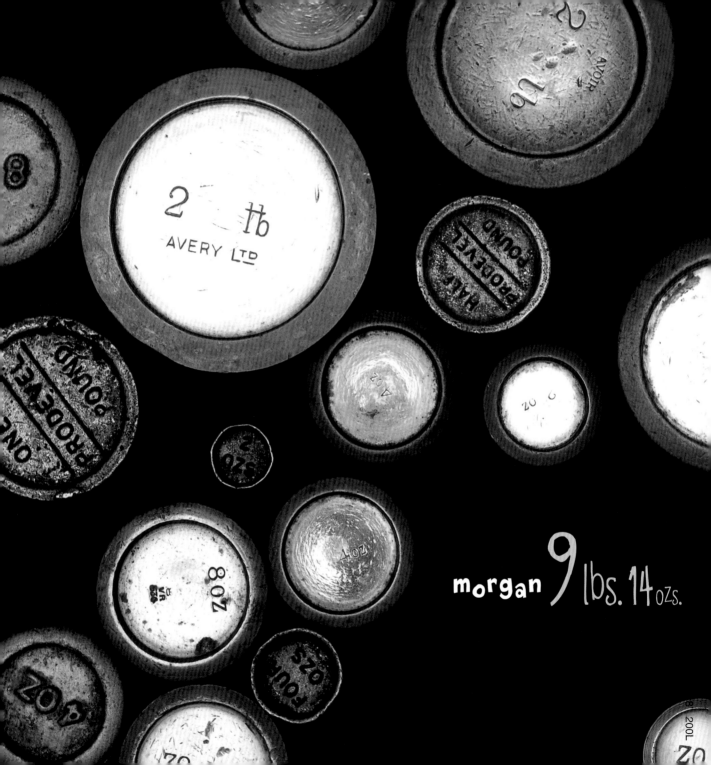

morgan 9 lbs. 14 ozs.

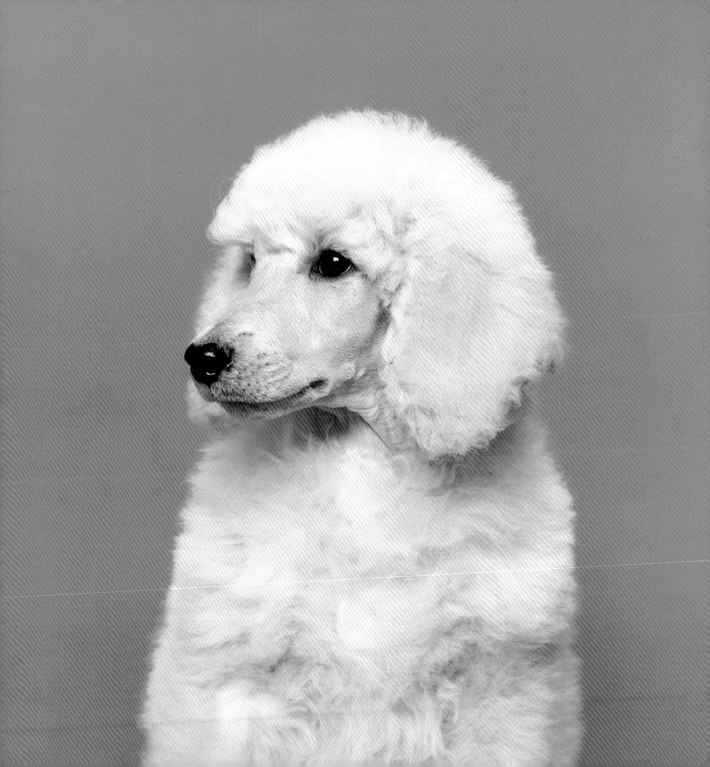

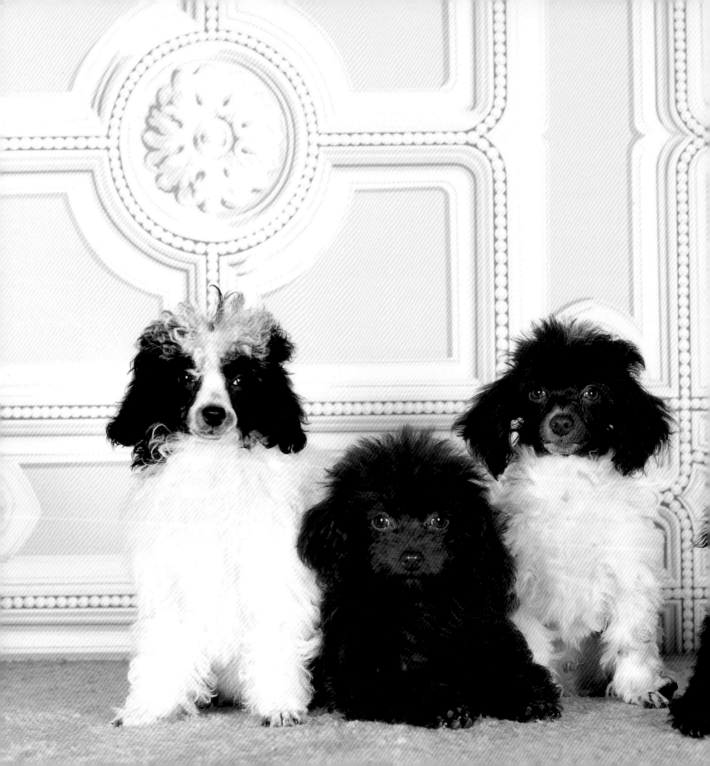

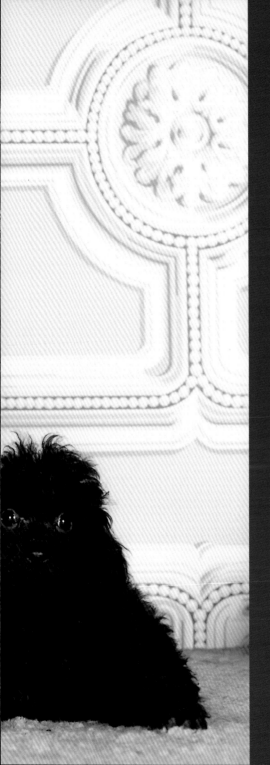

lightweights **littermates** eight weeks old

duchess 2 lbs. 15 ozs.

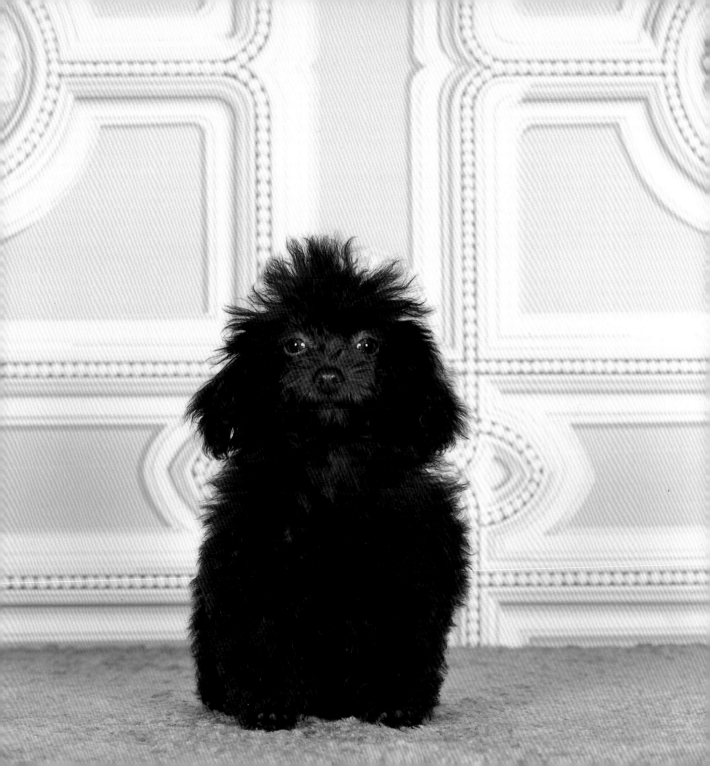

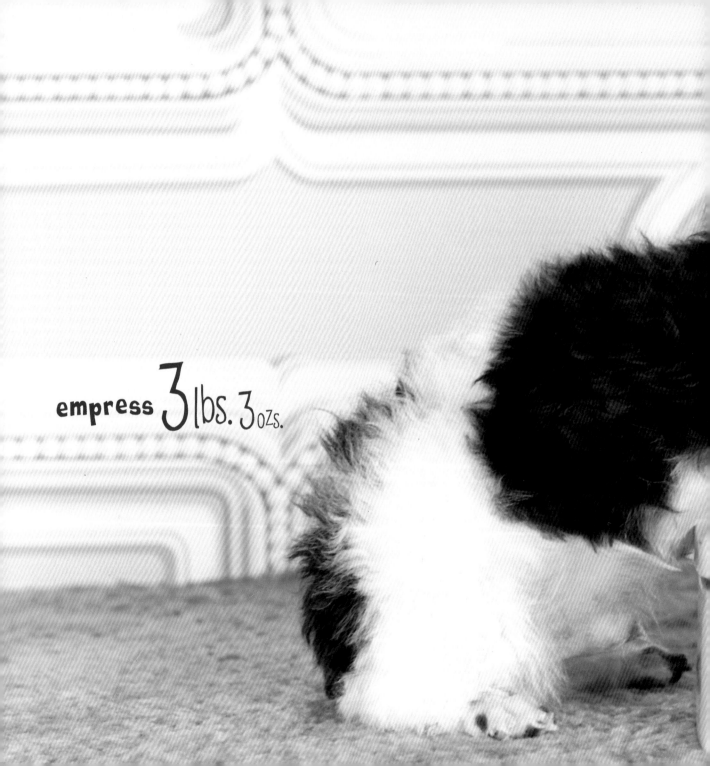

empress 3 lbs. 3 ozs.

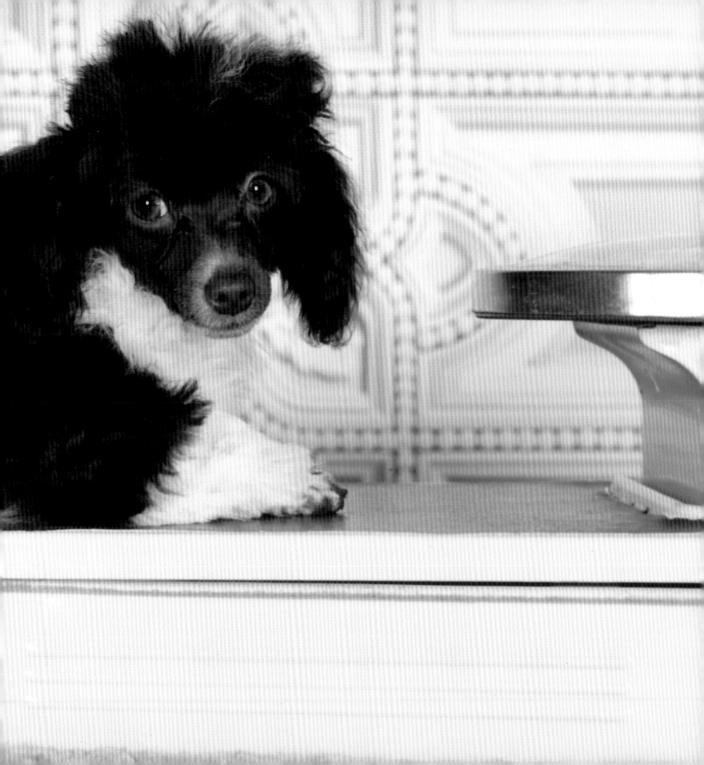

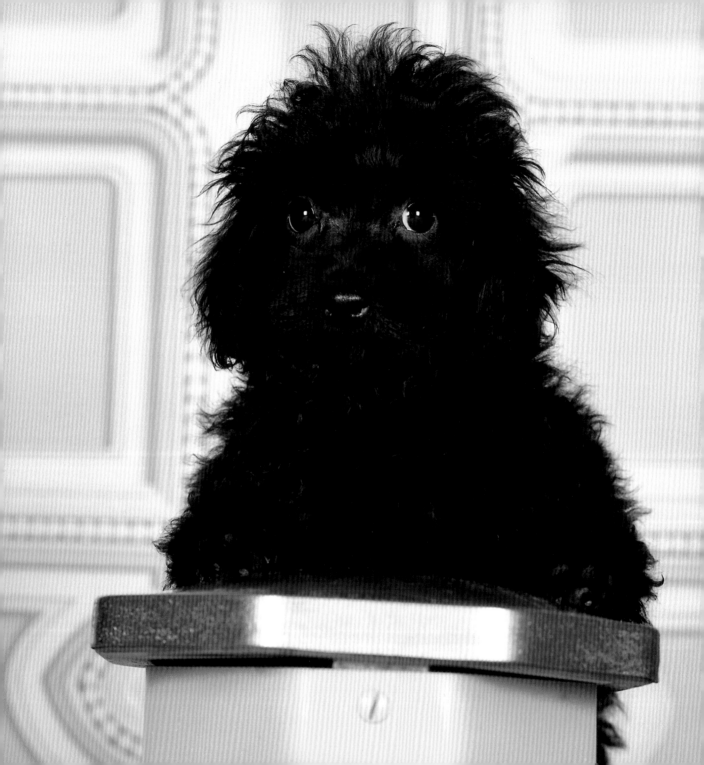

marie 3 lbs. 6 ozs.

archduke 3 lbs. 7 ozs.

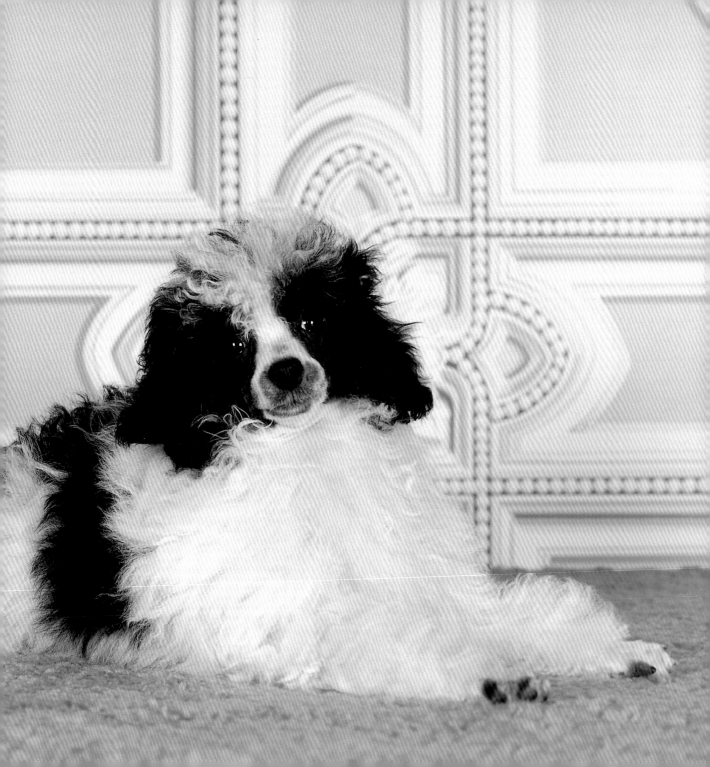

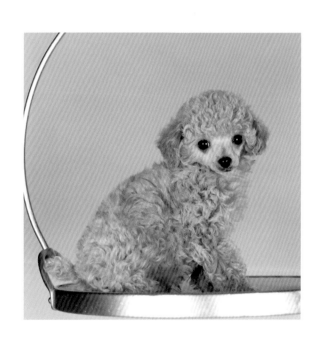

With many thanks to family and friends, as always.

Also, Hendrick and Sally.

Bob Weinberg.

My literary agent, Betsy Amster.

Leslie Stoker, Kristen Latta, and the whole staff at Stewart, Tabori and Chang.

Joe, Carlos Rios, Bonny, Ramesh, and everyone at the Icon.

All the adorable little puppies and their breeders.

A very special thank you to Jim Blackwell.

And, especially, Spencer Starr.

Puppies Provided by:

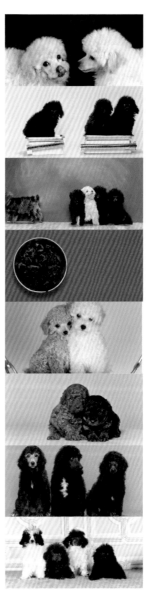

MADELINE PATTERSON

KAREN SISCO www.siscospoodles.com

JIM BLACKWELL www.toypoodlepuppies.net

KAREN SISCO www.siscospoodles.com

NORMA B. THOMPSON www.parti-poodles.com

KAREN SISCO www.siscospoodles.com

KAREN SISCO www.siscospoodles.com

NORMA B. THOMPSON www.parti-poodles.com